The Still
Bored
@Work

Pocket **Doodle** Book

THIS IS A CARLTON BOOK

Published in 2015 by Prion
An imprint of the Carlton Publishing Group
20 Mortimer Street
London W1T 3JW

Images copyright © 2009 Ross Adams
Design & layout copyright © 2015 Carlton Publishing Group

A CIP catalogue record for this book is available from the British Library

ISBN 978-1-85375-931-4

Printed in China

The Still Bored @Work

Pocket **Doodle** Book

Loads of ways to scribble away the daily grind

Rose Adders

PRION

Draw in this book

Colour in the images

Fill in the drawings

Stick things in it

Fill the pages with stuff

Cover the pages in
something more interesting

It's your book... use it!

Introduce yourself...

MY NAME IS:

I HATE MY JOB BECAUSE:

You don't have to be a

To work here,
But it helps.

Have the first word today...

...draw it BIG so the office can see it

Doodle your excuses for being late

Complete the desktop wildlife

CENTIPEN

SCISSOR BEAK

Complete the desktop wildlife

Complete the desktop wildlife

CROCO-STAPLER

Imagine your co-workers in fancy dress

Frank the mail

Complete the 12-step
Workaholics Program

① SURRENDER THE PROBLEM

② CALM DOWN

③ SUBMIT TOTALLY

④ SELF ANALYSE

Complete the 12-step
Workaholics Program

5 IDENTIFY PERSONAL GOALS

6 FLOOR THE HARDRIVE

7 RESET CHARACTER

8 APOLOGISE

Complete the 12-step Workaholics Program

9 PAY THE FINE

10 STAY TRUE AND OBJECTIVE

11 GET OUT OF TOWN

12 SPREAD THE WORD

Does your mouse have a life of its own?

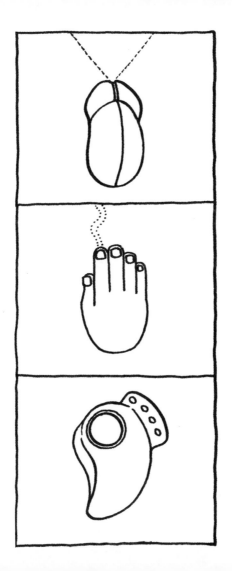

What is really going on
inside your computer?

Climb the middle management skyscraper - but don't fall between jobs!

What is on the keyboards?

Sort out the paper problem

What would you like to see on your desk first thing on Monday morning?

Rebrand the company logos

Rebrand the company logos

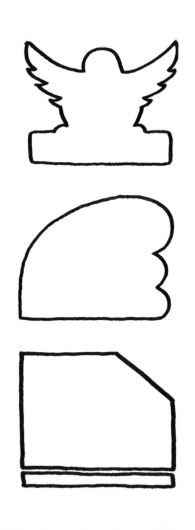

What else can you sweep under
the carpet?

Send a Trojan Horse into the
shared drive

Will you survive re-entry into the work atmosphere as you return from your travels?

Job hunting? Sell yourself...

NEW

YOUR NAME HERE:

YOUR UNIQUE SELLING POINT:

YOUR EYE-CATCHING IMAGE:

NOW WITH MORE

YOUR IMPROVED FEATURES:

PLUS

ONLY

£

PER ANNUM

Which colleague would you like to put on the coconut shy?

Read your career future in the cappuccino froth

FORECAST:

FORECAST:

FORECAST:

FORECAST:

Read your career future in the cappuccino froth

FORECAST:

FORECAST:

Bend these paperclips into new shapes
or useful tools

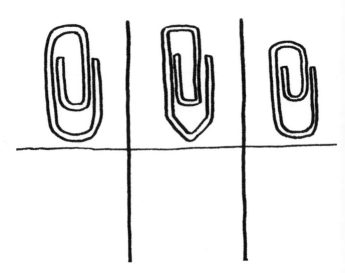

Bend these paperclips into new shapes
or useful tools

Draw yourself getting snapped up by the big fish or the loan shark

Use this page to help you follow those epic meetings

Complete your colleagues' notes

Somebody has left you a note...

You are in trouble... what have you done?

Come into my office

Write your own to-do list

Uh-oh. What did you have to rescue
from the paper shredder?

Draw some spanners
in the works

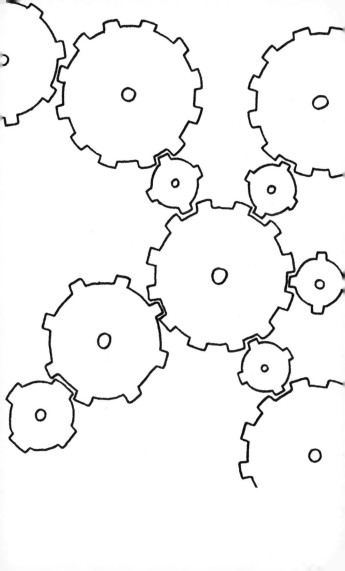

Launch some new branches

Save energy... and paint the bulbs black

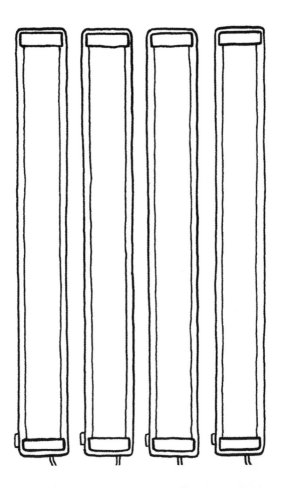

Write your own interview

AMAZING PHOTO:

AWARDS:

MY PERSONAL SPECIFICATIONS:

MY PERSONAL STATEMENT:

QUOTE YOURSELF: " "

ASK ME THESE QUESTIONS:	MY ANSWERS ARE:

YOU SHOULD EMPLOY ME BECAUSE:

Design your own Credit Crunch cereal
and eat it for breakfast!

Who is still on the sinking ship?

Make your big break bigger

Rate your job stability

FORTRESS ☐

SHACKLED ☐

PROTECTED ☐

COMFY CHAIR ☐

UNICYCLE

TIGHTROPE

CLINGING
ON

FINE LINE

FREEFALL

Arm the job hunters

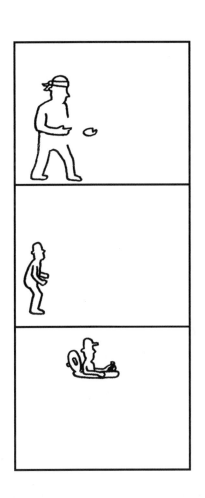

Sabotage the last page of Dave's flip chart presentation

What is going on under the desks?

Relocate the office to a more suitable location

What remedy will you prescribe when you pull a sickie?

MY SYMPTOMS:

Put some leaky pens in your shirt pocket

Judge this book by its cover

Dirty the competition

Summon the Tea Genie to grant you three cups of liquid refreshment

1ST CUP

2ND CUP

3RD CUP

Draw your own unique tea mug

After-hours drinks with
The Incredible Drunk

How will you get out of the red and into
the black?

Identify your greed and bad deeds

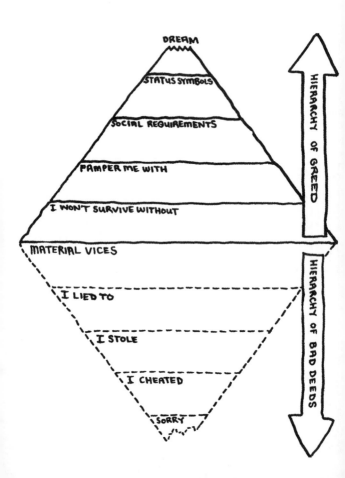

Brick up your office door

When do you finish work?

WHENEVER ☐

EARLY ☐

ON TIME ☐

LATE ☐

THE WAY HOME

ON THE SOFA

OVER DINNER

SMALL HOURS

NEVER

Add some small print, sign on the
dotted line and make sure you have
a witness

SIGNED:

CAN I GET A WITNESS?

SIGNED:

CAN I GET A WITNESS?

Design the cover of your autobiography

Hit your targets

Design a statue to commemorate the data entry staff who have fallen in action

Secure the big contract

How bright are your ideas?

Practise being patient with your computer

1ST WAIT :	2ND WAIT :	3RD WAIT :
__hrs __mins __secs	__hrs __mins __secs	__hrs __mins __secs

Award yourself a medal for services
beyond your call of duty

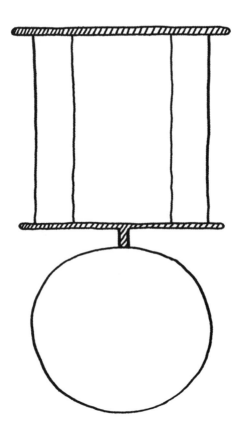

Design some new cufflinks for
your colleagues

Bury yourself in paperwork and complete your gravestone

Redecorate your workstation to feel more like home when you work weekends

Complete the Boards of Directors'
clubhouse photo

Gossip around the watercooler

Fix the sales figures to give them a more attractive outline

Make these workers tear their hair out

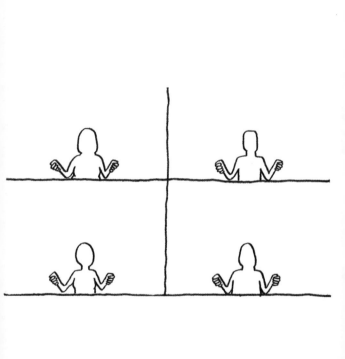

Draw the effects of different management styles on the staff faces

AUTHORITARIAN

PARENTAL

DEMOCRATIC

ABDICATION

FREE REIN

YOUR TURN

Will you pass your boss's lie detector test?

TRICKY QUESTIONS	YOUR RESPONSE		PASS?
DID YOU ARRIVE AT WORK ON TIME?			
♡			
HAVE YOU FINISHED THE ADMIN?			
♡			
HOW LONG DID YOU TAKE FOR LUNCH?			
♡			

TRICKY QUESTIONS	YOUR RESPONSE		PASS?
DID YOU MEET YOUR TARGET?			
♡			
HAVE YOU SENT THAT EMAIL?			
♡			
WHERE ARE THE BISCUITS?			
♡			

Map the communication pathways for office gossip

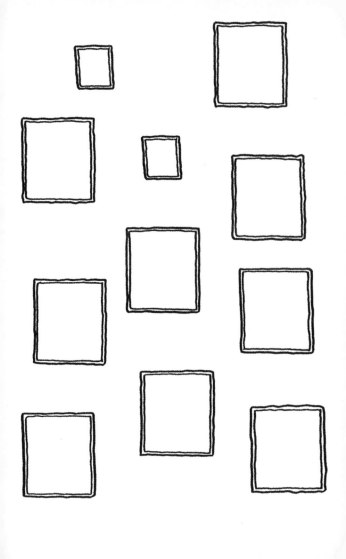

What can you see in the chad storm?

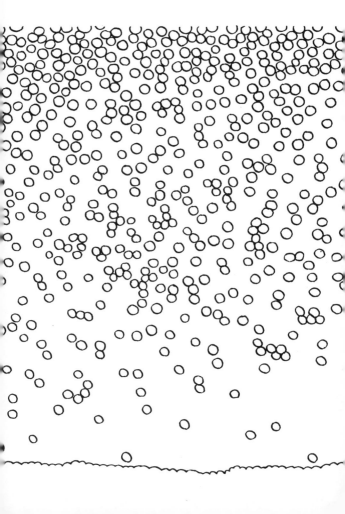

Find the weakest link in the chain of command

What is the best way to throw out the rule book?

Who has been shipwrecked?

FREELANCE SELF EMPLOYED SMALL BUSINESS ESTABLISHED

ECONOMIC GROWTH →

Boom

Bust

RECOVERY

Boom

RECESSION

Bust

0 TIME →

BIG BUSINESS

CORPORATE

SOLO

Board up the office and move on

What is helping these cheques bounce?

Make this meeting more interesting

Draw the biro at various stages of its life cycle

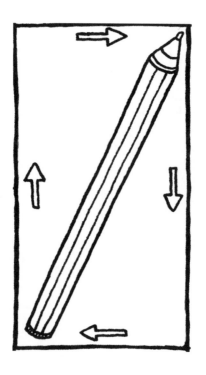

FOUND	USED TO WRITE	CHEWED
DROPPED BEHIND DESK		DEVELOPS TEMPORARY FAULT
USED AS PICKING TOOL		LEFT UNGUARDED
INK LEVEL DECEPTION	USED FOR DOODLING	CASUALLY STOLEN

How has work life aged you?

Turn the big bank bonus into bait

Write a musical score for the whistle blowers

Why is Dave better on paper than in an interview?

Write your evil alter-ego's CV

AMAZING PHOTO:

AWARDS:

MY PERSONAL SPECIFICATIONS:

MY PERSONAL STATEMENT:

QUOTE YOURSELF: " "

ASK ME THESE QUESTIONS:	MY ANSWERS ARE:

YOU SHOULD EMPLOY ME BECAUSE:

Customize your own mouse

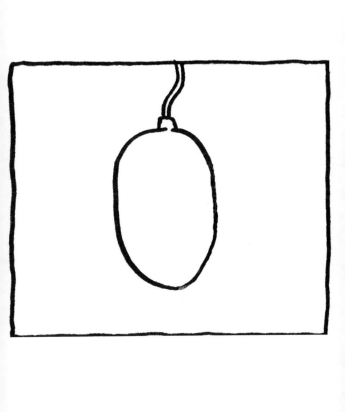

Design your perfect CV

NEW

YOUR NAME HERE:

YOUR UNIQUE SELLING POINT:

YOUR EYE-CATCHING IMAGE:

NOW WITH MORE

YOUR IMPROVED FEATURES:

PLUS

ONLY

PER ANNUM

Look in the mirror. What do you see?

Have the last laugh...

...doodle whatever's on your mind!

All I want is world peace and...

Make your own money

Draw yourself coming up for air

Is Dave looking for a job in the wrong place?

What does your office crush look like?

Talk down to your boss

Apologies for the all staffer but...

✉ _____

✉ _____

✉ _____

✉ _____

✉ _____

✉ _____

✉ _____

✉ _____

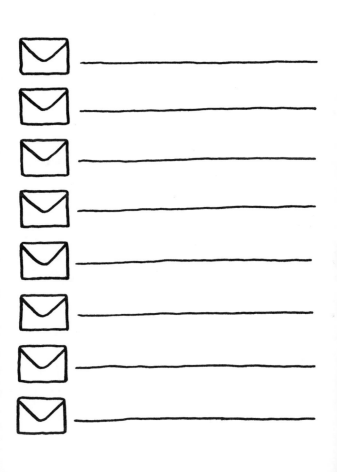

Doodle your own biscuit brand

Draw what you can see right now....

Write inside the leaving card of someone you dislike

Sorry to hear that you are leaving.

Give your computer even more bugs

Doodle your dream desk set up

Who is waiting for you at reception?

Keep yourself motivated today

SUCCESS

Discredit your colleague,
and you will shine.

Any celebrities at your dream
office party?

How would you kill time?

Plot your own learning curves

Draw a wacky tie!

Wake up the IT guy

Draw a masterpiece